Cats

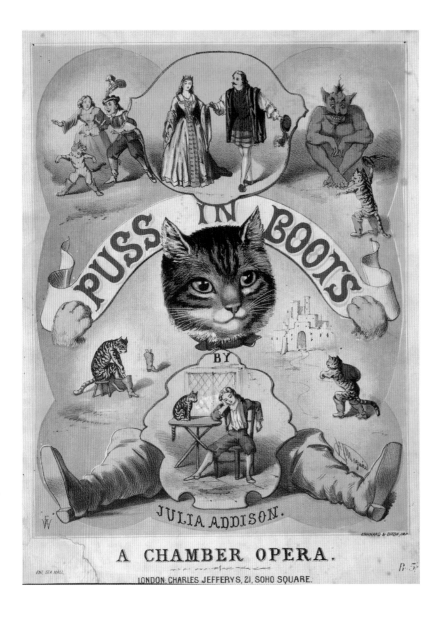

PUSS IN BOOTS

BY

JULIA ADDISON.

A CHAMBER OPERA.

LONDON. CHARLES JEFFERYS, 21, SOHO SQUARE.

The British Museum

Cats

Delia Pemberton

For Carolyn Jones: editor, cat-lover, friend

Copyright © 2006 The Trustees of the British Museum

Delia Pemberton has asserted her moral right to be identified as the author of this Work

First published in 2006 by the British Museum Press A division of the British Museum Company Ltd 38 Russell Square London WC1B 3QQ britishmuseum.org/publishing Paperback edition first published in 2015

A catalogue record for this book is available from the British Library

ISBN: 978-0-7141-5111-3

Designed by James Alexander at Jade Design Printed and bound in China by 1010 Printing International Ltd.

Frontispiece: Music cover sheet for Puss in Boots, tinted lithograph with hand colouring. London, c. 1843–1854. British Museum 1922,0710.702

Papers used by The British Museum Press are recyclable products made from wood grown in well-managed forests and other controlled sources. The manufacturing processes conform to the environmental regulations of the country of origin.

Contents

Introduction

He will kill mice, and he will be kind to Babies
when he is in the house, just as long as they do
not pull his tail too hard. But when he has done
that, and between times, and when the moon
gets up and night comes, he is the Cat that
walks by himself, and all places are alike to him.
Then he goes out to the Wet Wild Woods, or up
the Wet Wild Trees or on the Wet Wild Roofs,
waving his wild tail and walking by his wild lone.

Rudyard Kipling (1865–1936)
The Cat that Walked by Himself,
from *Just So Stories*, 1902

The story of the relationship between
humans and felines is as old as humanity
itself. In Kipling's story, a family of cave-
dwelling humans befriends first the Dog,
then the Horse, and finally the Cow, who
willingly serve them. The Cat, however,
has no interest in either friendship or
(heaven forbid) service. He negotiates
quite a different deal: in return for a
place in the cave, milk to drink and
the right to warm himself by the fire,
he agrees to catch mice and amuse the
children – but he will come and go as he
pleases.

It may be the fact that the domestic
cat remains a diminutive version of its
wild cousins that so appeals to modern
cat-lovers. When the moon gets up and
night comes, even the most pampered
puss will desert the fireside for the Wet
Wild Woods, or the Wet Wild Trees
or the Wet Wild Roofs. Perhaps the
presence of 'the tiger in the house' is a
reassuring link to our own wild selves,
a tenuous but precious connection to
the natural world from which we have
become so distanced. This certainly
seems to be the sentiment behind
William Blake's much-loved poem 'The
Tiger', a celebration of the miracle of
creation.

The cat's skill as controller of vermin
was of course much esteemed in the
agricultural economies of the ancient
world, where harvests were hoarded in
granaries against times of famine. In
Egypt, cats were deified, and their export
prohibited by law. In the 5th century
BC, Herodotus described the elaborate
funeral rites accorded by the Egyptians
to beloved family pets, while around
50 BC Diodorus of Sicily reported that
killing a cat in Egypt was a capital
offence. The value accorded to a cat in
the 10th-century laws of the Welsh king

Hywel Dda, proves that a good mouser remained a precious asset more than a thousand years later.

Equally, throughout history, the big cats – lions, tigers, panthers, and leopards – have been venerated and feared. From time immemorial, the fierce and regal lion was identified with kingship and war, and Assyrian kings and Egyptian pharaohs alike staged ceremonial lion-hunts to assert their divine power. Ramesses II, always one for the grand gesture, kept a pet lion that accompanied him into battle. And, just as Aztec Jaguar Warriors dressed as wild cats to inspire fear in their enemies, so Shakespeare's Henry V urges his troops to 'imitate the action of the tiger'.

Not that cats have always had it easy. In Kipling's tale, both the Man and the Dog swear eternal enmity to the Cat, and there have been many of both since who have followed their example. Several of the extracts in this book testify to the cat's reputation as cunning, cruel, greedy, duplicitous or just plain evil. In medieval Europe (and later America, as seen in the testimonies from the Salem witch trials) this led to the belief that witches and demons could take the shape of cats; in some cases the Devil himself was alleged to have appeared in feline form. In many cultures, the ritual torture and murder of cats was condoned until comparatively recent times.

In this book, I have tried to illustrate this long and complex relationship between humans and felines by drawing together some of the many and varied descriptions and depictions of cats – both big and small – from around the world and across time. The task has been both a delight and a torment: a delight because of the wealth of material, and a torment because constraints of space meant that many of my favourite words and images had to be omitted.

Apologies, then, to those readers, who do not find their favourites here – all anthologies inevitably come down to personal choices, and these are mine. Some, like Alexander Gray's 'On a Cat, Ageing', were old friends; others, like Adlai Stevenson's warm and witty summary of feline nature and Yakim-Addu's lion in the loft (how did it get there?) were new discoveries. The process of compiling the book, with its

frequent detours into the lives of writers, artists and their cats, was sheer delight.

Thanks are due first and foremost to my editor, friend and fellow cat-lover Carolyn Jones. I would also like to thank Lorna Oakes for finding the lion in the loft, Tina Rath for advising on Gothic cats and Oliver Roberts who helped with the Classical references. Many other friends and Museum colleagues, too numerous to name here, gave generously of their time, expertise and support. They know who they are, and how grateful I am. The entire process was of course supervised very closely by my own cat Mr Mars, who, like Mark Twain's immortal Tom Quartz, is 'nearly lightnin' on supervisin'.

We all hope you find pleasure between these covers.

The smallest feline is a masterpiece.

Leonardo da Vinci
(1452–1519)

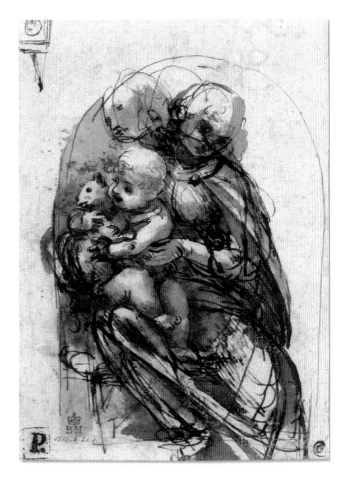

1. Leonardo da Vinci,
Virgin and Child with Cat.
Drawing, Italy, *c.*1478–81.

Suppertime

I wish you could see the two cats, drowsing
side by side in a Victorian nursing chair, their
paws, their ears, their tails complementally
adjusted, their blue eyes blinking open on
a single thought of when I shall remember
it's their suppertime. They might have been
composed by Bach for two flutes.

Sylvia Townsend Warner
(1893–1978)
Letter to William Maxwell, 1965

2. Christopher Wood,
Siamese Cats.
Coloured chalk drawing,
England, 1927.

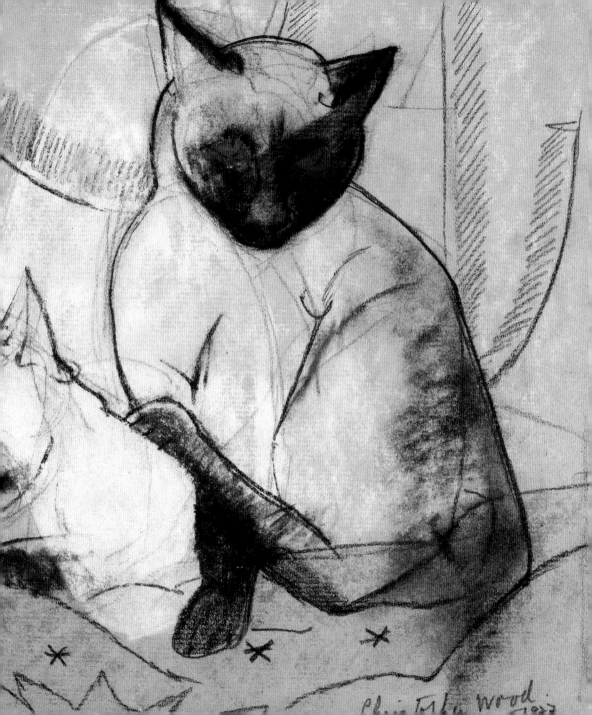

Le Chat

Viens, mon beau chat, sur mon coeur amoureux;
Retiens les griffes de ta patte,
Et laisse moi plonger dans tes beaux yeux,
Mêlés de métal et d'agate.

Lorsque mes doigts caressent à loisir
Ta tête et ton dos élastique,
Et que ma main s'enivre du plaisir
De palper ton corps électrique,

Je vois ma femme en esprit. Son regard,
Comme le tien, aimable bête,
Profond et froid, coupe et fend comme un dard,

Et, des pieds jusques à la tête,
Un air subtil, un dangereux parfum,
Nagent autour de son corps brun.

Charles Baudelaire (1821–1867)
From *Les Fleurs du mal* (**XXXIII**), 1857

3. Théophile Steinlen,
L'Hiver: Chat sur un coussin.
Colour lithograph, France,
1909.

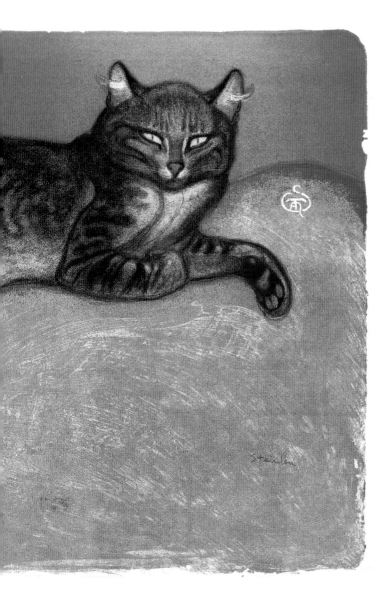

The Cat Sees Fuji

In the year's first dream
the cat sees Fuji…
I bet

Kobayashi Issa (1763–1827)

4. Utagawa Hiroshige,
*Ricefields in Asakusa on the Day of
the Torinomachi Festival.*
Polychrome woodblock print,
number 101 from the series *One
Hundred Famous Views of Edo,*
Japan, 1857.

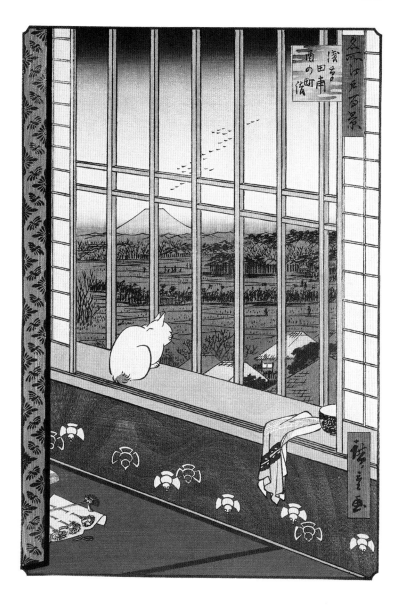

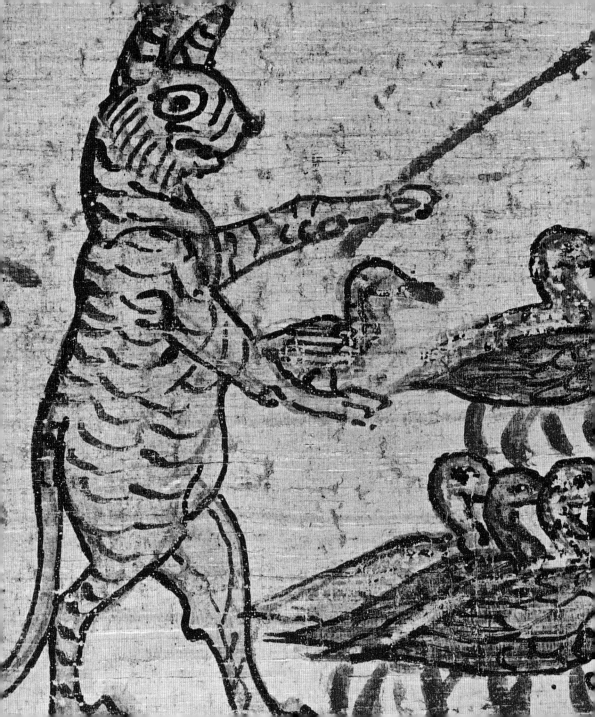

A Foster Mother

There are few animals who have a stronger attachment
for their young than the cat; and she has frequently
been known to transfer her affections to other young
animals, and to nurture them with much assiduity. She
is also capable of attaching herself to animals, that
are supposed to be naturally opposed to her, and with
whose nurture she had nothing to do…

A cat, belonging to a person in Taunton, having lost her
kittens, transferred her affections to two ducklings
which were kept in the yard adjoining. She led them out
every day to feed, seemed quite pleased to see them eat,
returned with them to their usual nest, and evinced as
much attachment for them as she could have shown to
her lost young ones.

Thomas Brown (1785–1862)
From *Interesting Anecdotes of the Animal Kingdom*, 1834

5. Cat and ducks, scene
from a satirical papyrus.
Late New Kingdom, Egypt,
c.1100 BC.

The Cheshire Cat

The Cat only grinned when it saw Alice. It looked good-natured, she thought: still it had *very* long claws and a great many teeth, so she felt that it ought to be treated with respect.

'Cheshire Puss,' she began, rather timidly, as she did not at all know whether it would like the name: however, it only grinned a little wider. 'Come, it's pleased so far,' thought Alice, and she went on. 'Would you tell me, please, which way I ought to go from here?'

'That depends a good deal on where you want to get to,' said the Cat.

'I don't much care where –' said Alice.

'Then it doesn't matter which way you go,' said the Cat.

'– so long as I get *somewhere*,' Alice added as an explanation.

'Oh you're sure to do that,' said the Cat, 'if you only walk long enough.'

Alice felt that this could not be denied, so she tried another question. 'What sort of people live about here?'

'In *that* direction,' the Cat said, waving its right paw round, 'lives a Hatter: and in *that* direction,' waving the other paw, 'lives a March Hare. Visit either you like: they're both mad.'

'But I don't want to go among mad people,' Alice remarked.

'Oh, you can't help that,' said the Cat: 'we're all mad here. I'm mad. You're mad.'

'How do you know I'm mad?' said Alice.

'You must be,' said the Cat, 'or you wouldn't have come here.'

Lewis Carroll (1832–1898)
From *Alice's Adventures in Wonderland*, 1865

6. Sir John Tenniel,
Alice and the Cheshire Cat.
Design engraved on wood
by the Dalziel Brothers,
England, 1865.

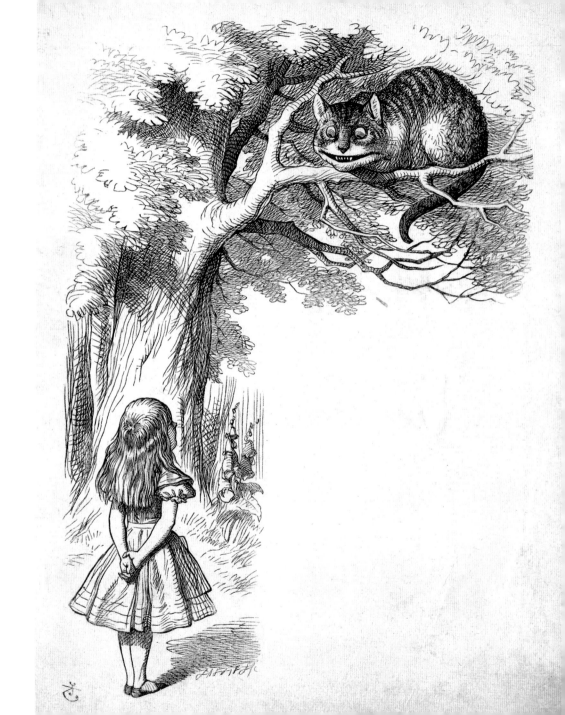

To Mrs Reynolds' Cat

Cat! who hast pass'd thy grand climacteric,
How many mice and rats hast in thy days
Destroy'd? How many tit bits stolen? Gaze
With those bright languid segments green,
　　and prick
Those velvet ears – but pr'ythee do not stick
Thy latent talons in me – and upraise
Thy gentle mew – and tell me all thy frays,
Of fish and mice, and rats and tender chick.
Nay, look not down, nor lick thy dainty wrists –
For all thy wheezy asthma – and for all
Thy tail's tip is nicked off – and though the fists
Of many a maid have given thee many a maul,
Still is that fur as soft, as when the lists
In youth thou enter'dest on glass-bottled wall.

John Keats (1795–1821)

7. Cornelis Visscher,
The Large Cat.
Engraving, The Netherlands, 1657.

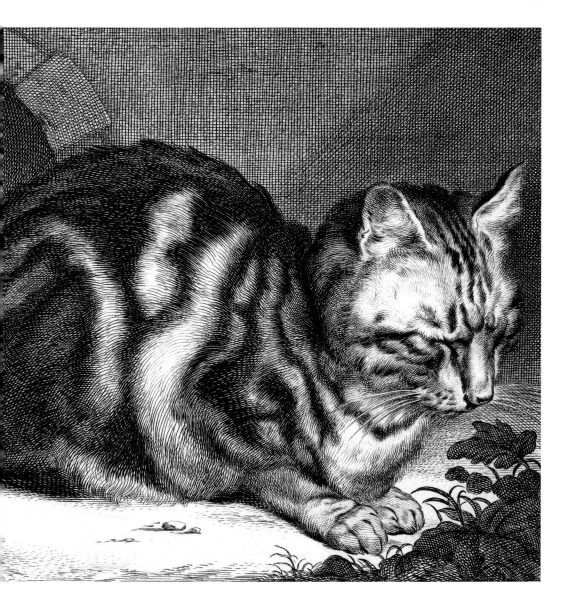

Belling the cat

Long ago, the mice had a general council to consider what measures they could take to outwit their common enemy, the Cat. Some said this, and some said that; but at last a young mouse got up and said he had a proposal to make, which he thought would meet the case. 'You will all agree,' said he, 'that our chief danger consists in the sly and treacherous manner in which the enemy approaches us. Now, if we could receive some signal of her approach, we could easily escape from her. I venture, therefore, to propose that a small bell be procured, and attached by a ribbon round the neck of the Cat. By this means we should always know when she was about, and could easily retire while she was in the neighbourhood.'

This proposal met with general applause, until an old mouse got up and said: 'That is all very well, but who is to bell the Cat?'

Moral: It is easy to propose impossible remedies.

From *Aesop's Fables*, 6th century BC

8. Francis Barlow
The Cat and Mice
Drawing
England, 1666

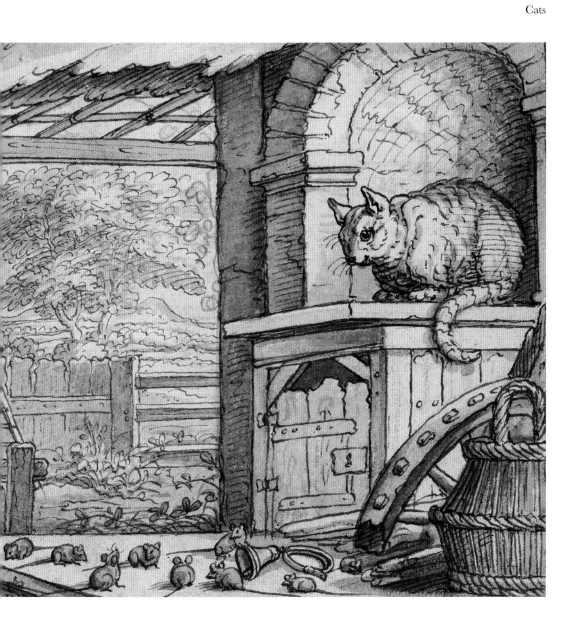

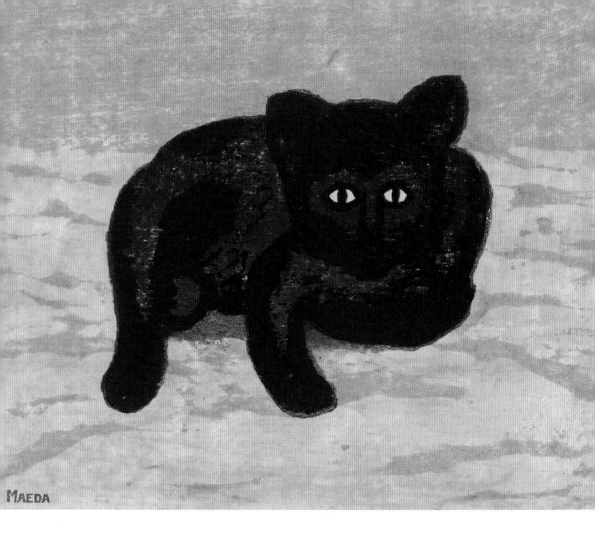

MAEDA

9. Maeda Masao, *Kuro Neko (Black Cat)*,
from *First Thursday Collection, Vol. 3*,
Colour woodblock print on paper
Japan, 1947 (printed 1960)

Black Cat

A ghost, though invisible, still is like a place
your sight can knock on, echoing; but here
within this thick black pelt, your strongest gaze
will be absorbed and utterly disappear:

just as a raving madman, when nothing else
can ease him, charges into his dark night
howling, pounds on the padded wall, and feels
the rage being taken in and pacified.

She seems to hide all looks that have ever fallen
into her, so that, like an audience,
she can look them over, menacing and sullen,
and curl to sleep with them. But all at once

as if awakened, she turns her face to yours;
and with a shock, you see yourself, tiny,
inside the golden amber of her eyeballs
suspended, like a prehistoric fly.

Rainer Maria Rilke (1875-1926)
Translated from the German by Stephen Mitchell

An Idle Man's Pastime

It is needless to spend any time over her loving nature
to man, how she flattereth by rubbing her skin against
one's legs, how she whurleth with her voice, having
as many tunes at turnes, for she hath one voice to beg
and to complain, another to testify her delight and
pleasure, another among her own kind by flattering, by
hissing, by puffing, by spitting, in so much that some
have thought that they have a peculiar intelligible
language among themselves. Therefore how she
playeth, looketh, leapeth, catcheth, tosseth with her
foot, riseth up to strings held over her head, sometimes
creeping, sometimes lying on the back, playing with
foot, apprehending greedily anything save the hand of
a man, with divers gestical actions, it is needless to stand
upon; in so much as Collins was wont to say, that being
free from his studies and more urgent weighty affairs,
he was not ashamed to play and sport himself with his
cat, and verily it may be called an idle man's pastime.

Edward Topsell (d.1638)
From *The Historie of Foure-Footed Beastes… * 1607

10. Théophile Steinlen,
front cover for *Dessins sans
Paroles des Chats.*
Colour lithograph, France,
1898.

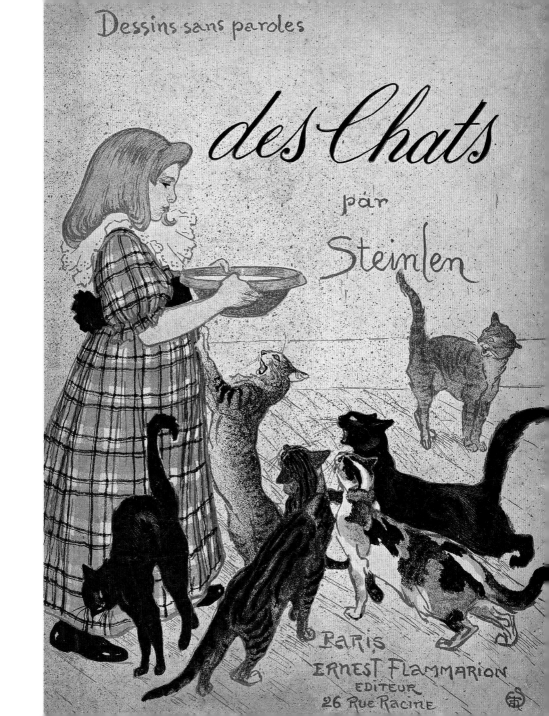

Dessins sans paroles

des Chats

par

Steinlen

PARIS
ERNEST FLAMMARION
EDITEUR
26 Rue Racine

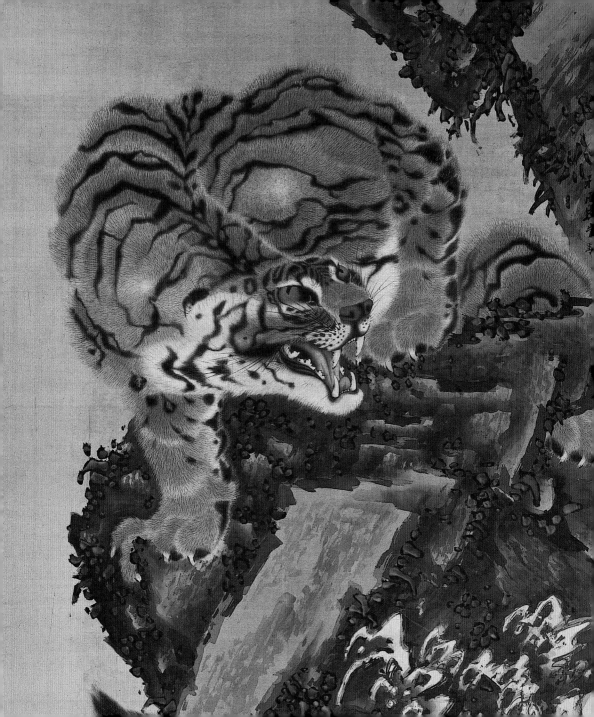

The Tiger

Tiger! Tiger! burning bright
In the forests of the night
What immortal hand or eye
Could frame thy fearful symmetry?

In what distant deeps or skies
Burnt the fire of thine eyes?
On what wings dare he aspire?
What the hand dare seize the fire?

And what shoulder, and what art,
Could twist the sinews of thy heart?
And when thy heart began to beat,
What dread hand? and what dread feet?

What the hammer? What the chain?
In what furnace was thy brain?
What the anvil? What dread grasp
Dare its deadly terrors clasp?

When the stars threw down their spears,
And watered heaven with their tears,
Did He smile His work to see?
Did He who made the Lamb make thee?

Tiger! Tiger! burning bright
In the forests of the night,
What immortal hand or eye
Dare frame thy fearful symmetry?

William Blake (1757–1827)
From *Songs of Experience*, 1794

11. Gan Ku,
Tiger.
Hanging scroll painting, Edo
period, Japan,
c.AD 1784–96.

Tom Quartz

Speaking of sagacity it reminds me of
Dick Baker, pocket miner of Deadhorse
Gulch. Whenever he was out of luck
and a little downhearted, he would fall
to mourning over the loss of a wonderful
cat he used to own (for where women
and children are not, men of kindly
impulses take up with pets, for they must
love something.) And he always spoke of
the strange sagacity of that cat with the
air of a man who believed in his secret
heart that there was something human
about it – may be even supernatural.

I heard him talking about this animal
once. He said, 'Gentlemen, I used to
have a cat here, by the name of Tom
Quartz, which you'd a took an interest

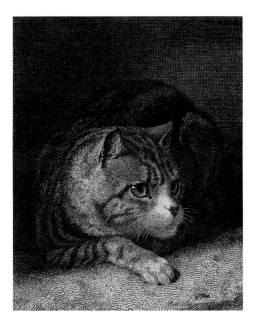

in I reckon – most any body would. I
had him here 8 year – and he was the
remarkablest cat I ever see. He was a
large gray one of the Tom specie, and

12. (After) Abraham Cooper, *Tom*
Book illustration
London, 1824

he had more hard, nat'ral sense than any man in this camp – and a *power* of dignity – he wouldn't a let the Gov'ner of California be familiar with him. He never ketched a rat in his life – 'peared to be above it. He never cared for nothing but mining. He knowed more about mining, that cat did, than any man I ever see. You couldn't tell *him* nothing about placer diggings – and as for pocket mining, why he was just born for it. He would dig out after me and Jim when we went over the hills prospecting, and he would trot along behind us for as much as five mile, if we went so far. And he had the best judgment about mining ground – why you never see anything like it. When we went to work, he'd scatter a glance around, and if he didn't think much of the indications, he would give a look as much as to say, "Well, I'll have to get you to excuse *me*," and without another word he'd hyste his nose into the air and shove for home. But if the ground suited him, he would lay low and keep dark till the first pan was washed and then he would sidle up and take a look, and if there was about six or seven grains of gold *he* was satisfied – he didn't want no better prospect'n that – and then he would lay down on our coats and snore like a steamboat till we'd struck the pocket, and then get up and superintend.'

Mark Twain (1835–1910)
From the Buffalo *Express*,18 December 1869

No Good

Cats are, of course, no good. They're chisellers and panhandlers, sharpers and shameless flatterers. They are as full of schemes and plans, plots and counterplots, wiles and guiles as any confidence man. They can read your character better than a $50 an hour psychiatrist. They know to a milligram how much of the old oil to pour on to break you down. They are definitely smarter then I am, which is one reason why I love 'em…

Of all the things a smart cat can do to whip you into line, the gift of a mouse is the cleverest and most touching… How can you mark it up except as rent, or thanks, or Here, looka: this is the most important thing I can do. You take it because I like you?

How come Kitty acts not like the beast of prey she is but like a better-class human being? I don't know the answer. The point is, she does it – and makes you her slave ever after. Once you have been presented with a mouse by your cat, you will never be the same again. She can use you for a doormat. And she will, too.

Paul Gallico (1897–1976)
From *My Boss, the Cat*, 1964

13. Orovida Camille Pissaro,
Just Cats.
Etching with aquatint, 1948.

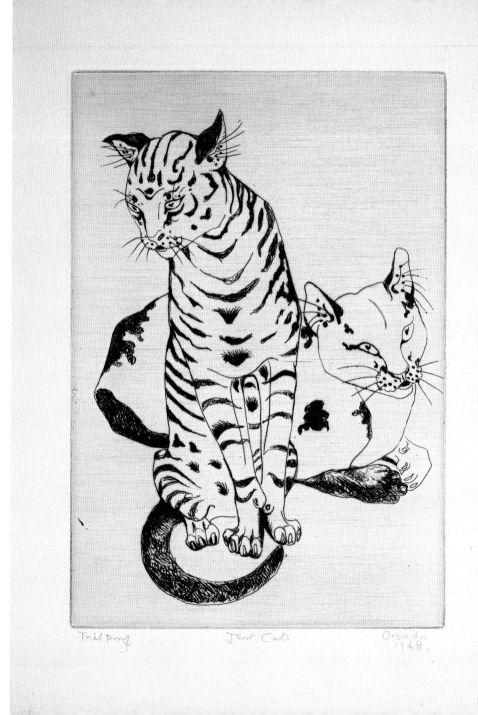

Trial proof Jew' Cats Orondor
 1948.

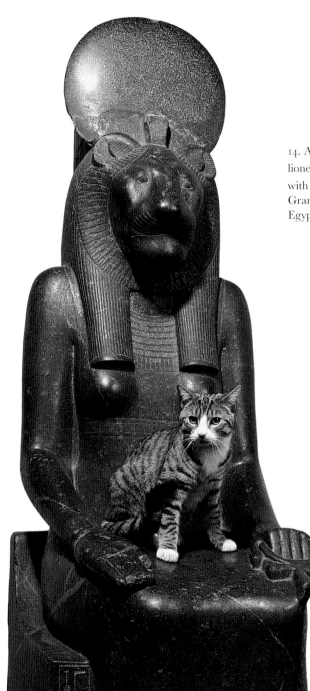

14. A statue of the Egyptian
lioness goddess Sekhmet,
with a visitor.
Granite.
Egypt, 1390–1352 BC.

A British Museum Cat

In the days when that famous and learned man, Sir Richard Garnett, ruled over the Department of Printed Books in the British Museum, he was frequently visited by a cat who was generally known among the staff as 'Black Jack'.

He was a very handsome black creature, with a white shirt front, and white paws, and whiskers of great length. He was fond of sitting on the desks in the Reading Room, and he never hesitated to ask a reader to hold open both folding doors when he wanted to go out into the corridor. Being shut in one of the newspaper rooms one Sunday, and being bored, he amused himself by sharpening his claws on the bindings of the volumes of newspapers, and it must be confessed did much damage. This brought down upon him the wrath of the officials, and he was banished from the library; the Clerk of the Works was ordered to get rid of him, and tried to do so, but failed, for Black Jack had disappeared mysteriously. The truth was that two of the members of the staff arranged for him to be kept in safety in a certain place, and provided him with food and milk. An official report was written to the effect that Black Jack had disappeared, and he was 'presumed dead'; the bindings of the volumes of newspapers were repaired, and the official mind was once more at peace. A few weeks later, Black Jack reappeared, and everyone was delighted to see him again; and the chief officials asked no questions!

Sir E.A. Wallis Budge (1857–1934)
From *Mike*, 1934

Cat or Lioness?

When a man smells of myrrh his wife is a
 cat before him.
When a man is suffering his wife is a lioness
 before him.

The Instruction of Ankhsheshonq (15, 11–12)
1st century BC or earlier
Translated from the Demotic
by Miriam Lichtheim

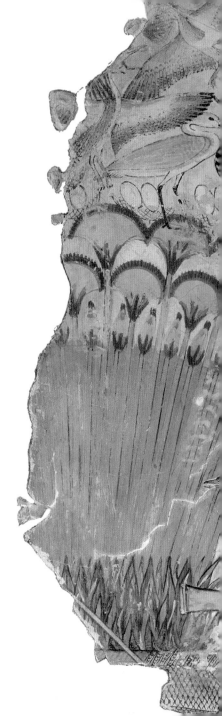

15. *Fowling in the Marshes.*
Fragment of wall painting
from the tomb of Nebamun.
Thebes, Egypt, 18th Dynasty,
*c.*1350 BC.

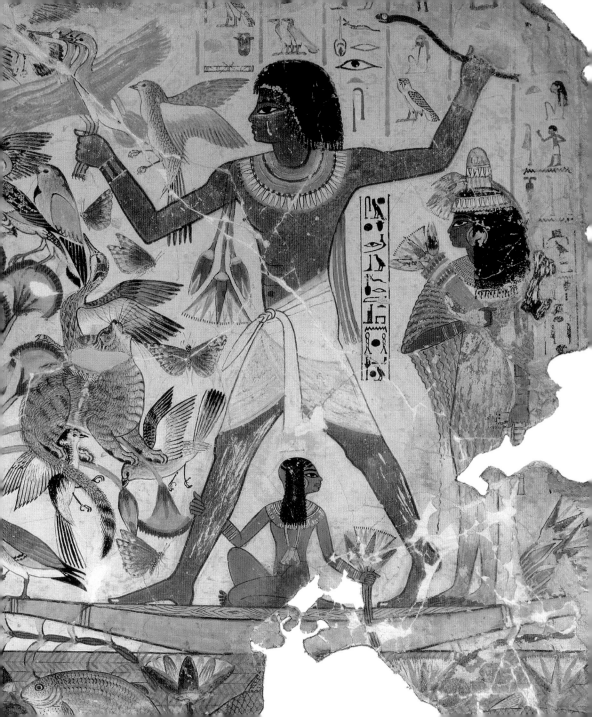

Egyptian Cats

What happens when a house catches
fire is most extraordinary: nobody
takes the least trouble to put it out, for
it is only the cats that matter: everyone
stands in a row, a little distance from
his neighbour, trying to protect the cats,
who nevertheless slip through the line,
or jump over it, and hurl themselves into
the flames. This causes the Egyptians
great distress.

All the inmates of a house where a
cat has died a natural death shave
their eyebrows… Cats which have
died are taken to Bubastis, where they
are embalmed and buried in sacred
receptacles.

Herodotus (*c.*485–425 BC)
Histories II. 65–67

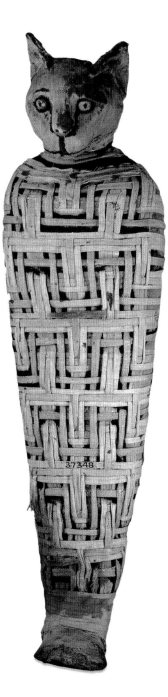

16. Mummy of a cat.
From Abydos, Egypt.
Roman period, perhaps
1st century AD.

38

The Value of a Cat

The worth of a kitten from the night it is kittened until it shall open its eyes is a legal penny; and from that time until it shall kill mice, two legal pence; and after it shall kill mice, four legal pence; and so it shall always remain. The qualities of a cat are to see, to hear, to kill mice, to have her claws entire, to rear and not to devour her kittens, and if she be bought and be deficient in any of these qualities, let one third of her worth be returned.

The worth of a cat that is killed or stolen: its head is to be put downwards upon a clean, even floor, with its tail lifted upwards, and thus suspended, whilst wheat is poured about it, until the tip of its tail be covered and that is to be its worth; if the corn cannot be had, a milch sheep with her lamb and its wool is its value, if it be a cat which guards the King's barn. The worth of a common cat is four legal pence.

From the Laws of Hywel Dda, 10th century AD

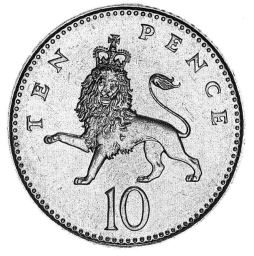

17. Modern 10p coin (reverse). Britain.

A Very Fine Cat

I never shall forget the indulgence with which he
treated Hodge, his cat: for whom he himself used to
go out and buy oysters, lest the servants having that
trouble should take a dislike to the poor creature. I
am, unluckily, one of those who have an antipathy to
a cat, so that I am uneasy when in the room with one;
and I own, I frequently suffered a good deal from the
presence of this same Hodge. I recollect him one day
scrambling up Dr Johnson's breast, apparently with
much satisfaction, while my friend smiling and half-
whistling, rubbed down his back, and pulled him by
the tail; and when I observed he was a fine cat, saying,
'Why yes, Sir, but I have had cats whom I liked better
than this'; and then as if perceiving Hodge to be out of
countenance, adding, 'but he is a very fine cat, a very
fine cat indeed.'

James Boswell (1740–1795)
From *The Life of Samuel Johnson LL.D.*, 1799

18. Nightlight-holder in the
shape of a cat.
Enamelled porcelain, China,
AD 1662–1722.

Mutual Entertainment

… As the learned and ingenious Montaigne says like
himself freely, When my cat and I entertain each other
with mutual apish tricks, as playing with a garter, who
knows but that I make my cat more sport than she
makes me? Shall I conclude her to be simple, that has
her time to begin or refuse to play as freely as I myself
have? Nay, who knows but that it is a defect of my not
understanding her language (for doubtless cats talk and
reason with one another) that we agree no better? And
who knows but that she pities me for being no wiser
than to play with her, and laughs and censures my folly
for making sport for her, when we two play together?

Sir Izaak Walton (1593–1683)
From *The Compleat Angler, or,
the Contemplative Man's Recreation*, 1653

19. Two ladies with a pigeon
and a cat, on a painted
Campanian-style vase.
From Avella, Italy, 2nd half of
the 4th century BC.

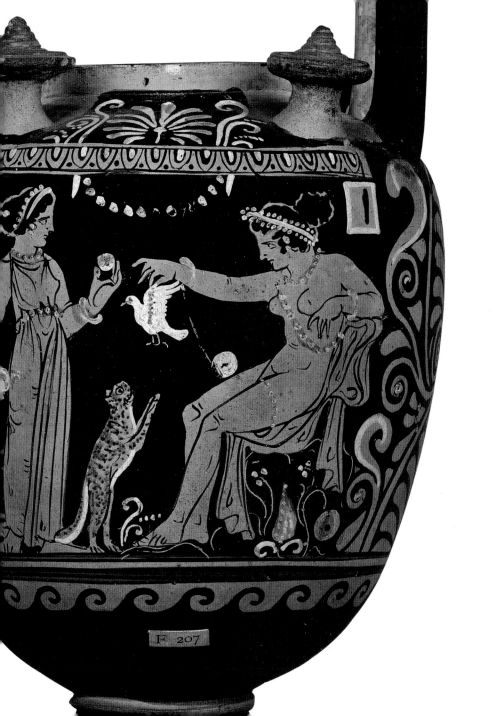

F 207

An Insectivorous Propensity

It may here be observed that the cat is even sometimes of a slightly insectivorous propensity. Young, sportive cats, more especially, have much amusement in playing with cockroaches, and sometimes eat them. But they appear to eat them more from accident or idleness then from desire…

Occasionally, pussy will be fortunate in catching such rare game as a cricket. Flies are not easily caught, except in a window; and they are said to make cats thin. Beetles, I think, do a cat no harm.

Philip M. Rule
From *The Cat: Its Natural History, Domestic Variations, Management and Treatment*, 1887

20. Yamamoto Ranei,
Cat Among Flowers Watching Insects.
Hanging scroll, ink and colours on silk, Japan, 17th century AD.

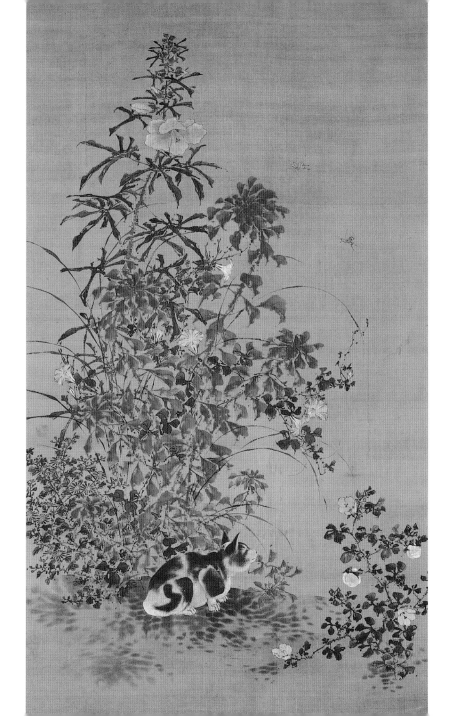

Shape-shifting

Robert Downer testifyed, That this Prisoner being some
years ago prosecuted at Court for a Witch, he then said
unto her, He believed she was a Witch. Whereat she
being dissatisfied, said, That some Shee-Devil would
Shortly fetch him away! Which words were heard by
others, as well as himself. The Night following, as he lay
in his Bed, there came in at the Window the likeness
of a Cat, which Flew upon him, took fast hold of his
Throat, lay on him a considerable while, and almost
killed him. At length he remembred what Susanna
Martin had threatned the Day before; and with much
striving he cryed out, 'Avaunt, thou Shee-Devil! In the
Name of God the Father, the Son, and the Holy Ghost,
Avaunt!' Whereupon it left him, leap'd on the Floor,
and Flew out at the Window. . .

Evidence given at the trial of Susanna Martin, at Salem,
Massachusetts, June 29, 1692

21. Theodule Ribot, *Three
Witches*
Chalk drawing on paper
France, 19th century

The Cat who Walked by Himself

He will kill mice and he will be kind to Babies when
he is in the house, just as long as they do not pull his
tail too hard. But when he has done that, and between
times, and when the moon gets up and night comes, he
is the Cat that walks by himself, and all places are alike
to him. Then he goes out to the Wet Wild Woods or up
the Wet Wild Trees or on the Wet Wild Roofs, waving
his wild tail and walking by his wild lone.

Rudyard Kipling (1865–1936)
The Cat who Walked by Himself, from *Just So Stories*, 1902

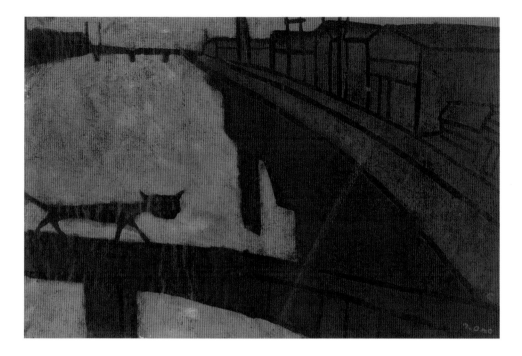

22. Tadashige Ono, *River* (detail)
Woodblock print
Japan, 1957

Once mounted on a tiger, it is difficult to get off.

Chinese proverb

23. *Gazi Riding a Tiger.*
Scene from the *Legend of Gazi.*
Scroll painting.
Bengal, India, *c.* 1800.

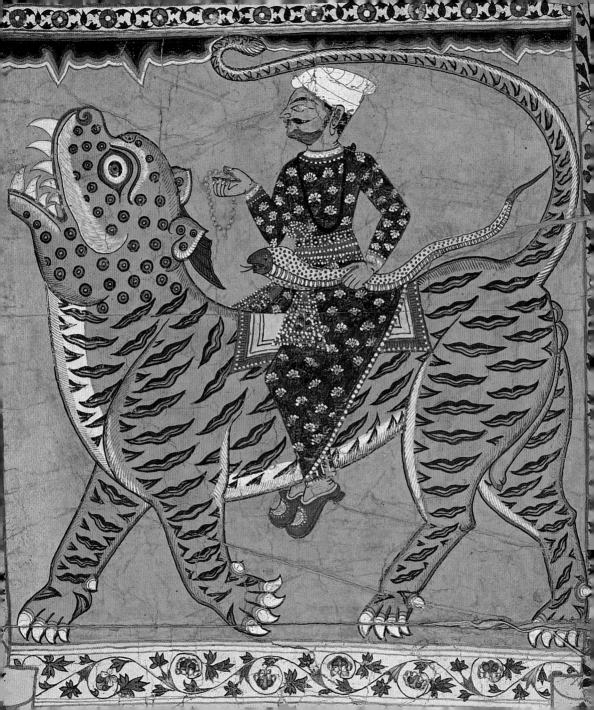

The Tigress

The tiger is named for its swiftness in flight; the Persians and Greeks call it 'arrow'. It is a beast distinguished by its varied markings, its courage and its extraordinary speed. The Tygris takes its name from the tiger, because it is the fastest-flowing of all rivers. Hircania is their main home.

The tigress, when she finds her lair empty by the theft of a cub, follows the tracks of the thief at once. When the thief sees that, even though he rides a swift horse, he is outrun by her speed, and that there is no means of escape at hand, he devises the following deception. When he sees the tigress growing close, he throws down a glass sphere. The tigress is deceived by her own image in the glass and thinks it is her stolen cub. She abandons the chase, eager to gather up her young. Delayed by the illusion, she tries once again with all her might to overtake the rider and, urged on by her anger, quickly threatens the fleeing man. Again he holds up her pursuit by throwing down a sphere. The memory of the trick does not banish the mother's devotion. She turns over the empty likeness and settles down as if to suckle her cub. And thus, trapped by the intensity of her sense of duty, she loses both her revenge and her child.

From the *Aberdeen Bestiary*, *c.*AD 1200
Translated from the Latin by Colin McLaren

24. Silver tigress from the Hoxne hoard. Roman Britain, buried in the 5th century AD. Found at Hoxne, Suffolk, in 1992.

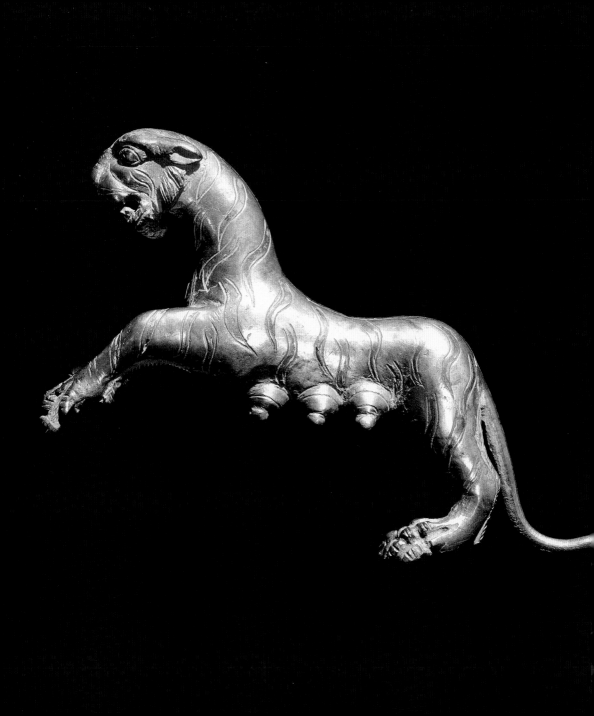

Schrödinger's Cat

To illustrate the non-intuitive nature of the quantum
world, Schrödinger offered a famous thought
experiment in which a hypothetical cat was placed in a
box with one atom of a radioactive substance attached
to a vial of hydrocyanic acid. If the particle degraded
within one hour, it would trigger a mechanism that
would break the vial and poison the cat. If not, the
cat would live. But we could not know which was the
case, so there was no choice, scientifically, but to regard
the cat as 100 per cent alive and 100 per cent dead at
the same time. This means, as Stephen Hawking has
observed with a touch of understandable excitement,
that one cannot 'predict future events exactly if one
cannot even measure the present state of the universe
precisely!'

Bill Bryson (1951–)
From *A Short History of Nearly Everything*, 2003

25. George Cruikshank, *Cat*
from *George Cruikshank's Omnibus*
Woodcut on paper
London, 1842

Lion in the Loft

Tell my lord: Your servant Yakim-Addu sends the
following message:

A short time ago I wrote to my lord as follows:
'A lion was caught in the loft of a house in
Akkaka. My lord should write me whether this
lion should remain in that same loft until the
arrival of my lord, or whether I should have it
brought to my lord.' But letters from my lord
were slow in coming and the lion has been in the
loft for five days. Although they threw him a dog
and a pig, he refused to eat them. I was worrying:
'Heaven forbid that this lion pine away.' I
became scared, but eventually I got the lion into
a wooden cage and loaded it on a boat to have it
brought to my lord.

Letter from Yakim-Addu to the King of Mari
(ARM 2 106), mid-18th century BC
Translated from the Old Babylonian by A. Leo Oppenheim

26. Bronze weight in the
form of a lion.
From Nimrud,
northern Iraq.
Neo-Assyrian, 9th–8th
century BC.

A Terrible Aspect

But when the blast of war blows in our ears,
Then imitate the action of the tiger;
Stiffen the sinews, conjure up the blood,
Disguise fair nature with hard-favoured rage;
Then lend the eye a terrible aspect...

William Shakespeare (1564–1616)
King Henry, in *Henry V,* Act 3, sc. 1

27. Orovida Camille Pissarro,
Tiger Crouching.
Colour aquatint with some
etching, England.

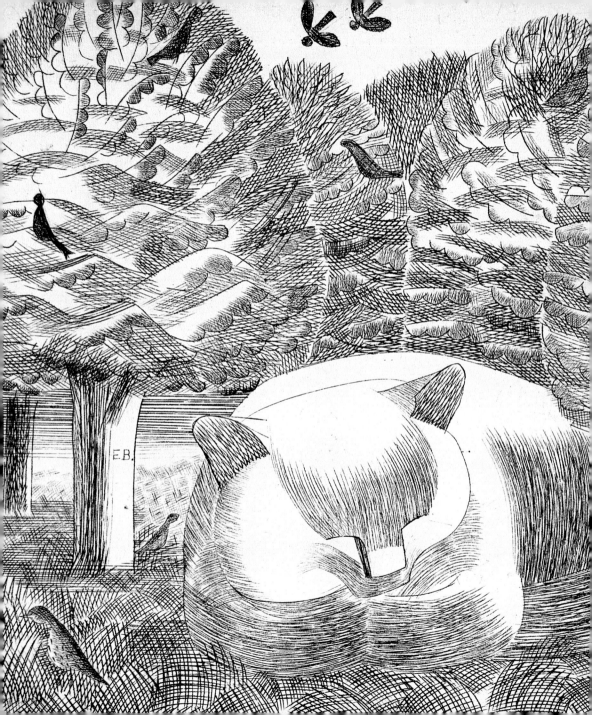

On a Cat, Ageing

He blinks upon the hearth-rug,
and yawns in deep content,
accepting all the comforts
that Providence has sent.

Louder he purrs, and louder,
in one glad hymn of praise
for all the night's adventures,
for quiet, restful days.

Life will go on for ever,
with all that cat can wish:
warmth and the glad procession
of fish and milk and fish.

Only – the thought disturbs him –
he's noticed once or twice,
the times are somehow breeding
a nimbler race of mice.

Sir Alexander Gray (1882–1968)

28. Edward Bawden,
Reverie.
Engraving, England, 1927–28.

A Strong Foe

I have (and long shall have) a white great nimble cat,
A king upon a mouse, a strong foe to a rat,
Fine eares, long tail he hath, with Lion's curbed clawe,
Which oft he lifteth up, and stayes his lifted pawe,
Deepe musing to himselfe, which after-mewing showes,
Till with lickt beard, his eye of fire espie his foes.

Sir Philip Sidney (1554–86)
From *Arcadia*, 1598

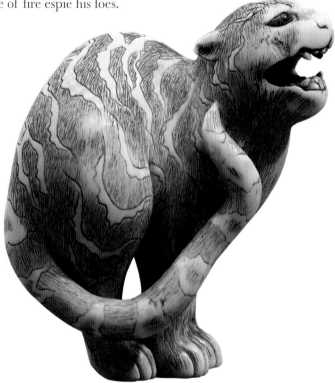

29. Netsuke tiger.
Ivory, Japan, 19th century.

For every home is
incompleat without him
and a blessing is lacking
in the spirit.

Christopher Smart (1722–1771)
From *Jubilate Agno*, *c.*1760

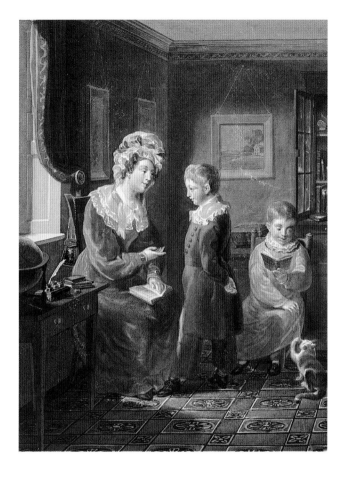

30. George Scharf I
(1788–1860),
The Artist's Family.
Watercolour, 1830.

Cat's Eyes

As to its Eyes, Authors say that they shine in the Night; and see better at the full, and more dimly at the change of the Moon. Also that the Cat doth vary his Eyes with the Sun; the Pupil being round at Sunrise, and long towards the Noon, and not to be seen at all at Night, but the whole Eye shining in the darkness. These appearances of the Cat's Eyes, I am sure are true; but whether they answer to the times of Day, I have never observed.

William Salmon (fl. late 17th century AD)
From *The Compleat English Physician, or the Druggist's Shop Opened*, 1693

31. Ying Chen, *Cat*.
Hanging scroll, colours on silk,
China, 19th century AD.

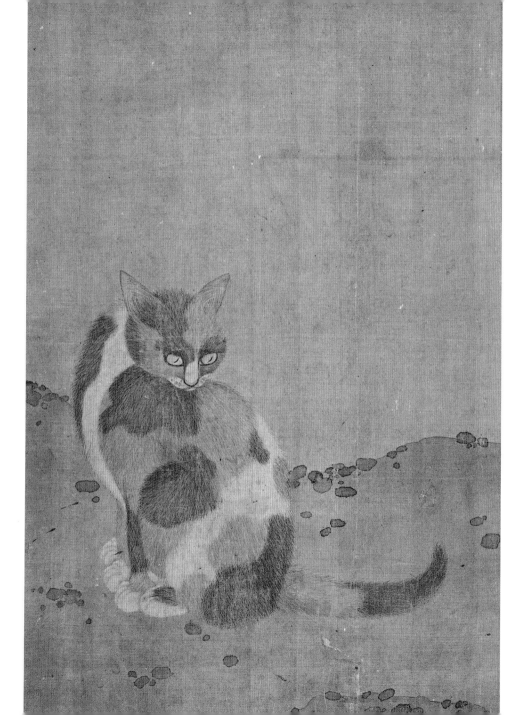

The Lion and Albert

There were one great big Lion called Wallace;
His nose were all covered with scars –
He lay in a somnolent posture,
With the side of his face on the bars.

Now Albert had heard about Lions,
How they was ferocious and wild –
To see Wallace lying so peaceful,
Well, it didn't seem right to the child.

So straightway the brave little feller,
Not showing a morsel of fear,
Took his stick with its 'orse's 'ead 'andle
And pushed it in Wallace's ear.

You could see that the Lion didn't like it,
For giving a kind of a roll,
He pulled Albert inside the cage with 'im,
And swallowed the little lad 'ole.

Then Pa, who had seen the occurrence,
And didn't know what to do next,
Said 'Mother! Yon Lion's 'et Albert',
And Mother said 'Ee, I am vexed!'

Marriott Edgar (1880–1951)
From *The Lion and Albert*, 1932

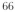

32. Peter Paul Rubens,
A Seated Lion (detail).
Chalk and wash
watercolour.

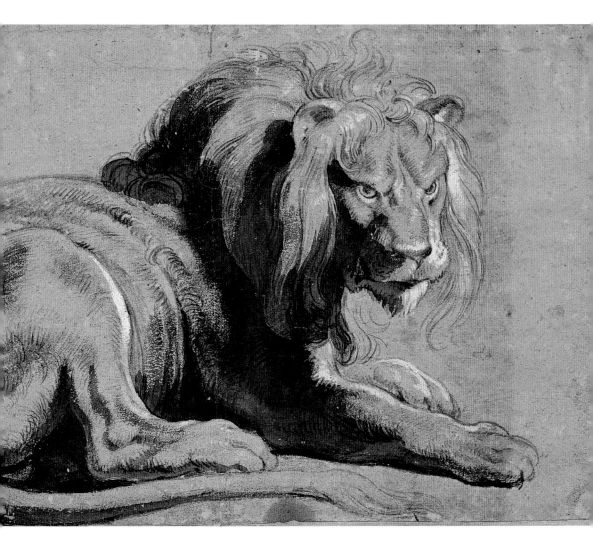

Useful but Deceitful

The *domesticus*, or tame cat, is so well known, that it requires no description. It is a useful, but deceitful domestic. Although when young they are playful and gay, they possess at the same time an innate malice and perverse disposition, which increases as they grow up, and which education learns them to conceal, but never to subdue. Constantly bent upon theft and rapine, though in a domestic state, they are full of cunning and dissimulation; they conceal all their designs; seize every opportunity of doing mischief, and then fly from punishment. They easily take on the habits of society, but never its manners; for they have only the appearance of friendship and attachment. This disingenuity of character is betrayed by the obliquity of their movements and the ambiguity of their looks. In a word, the cat is totally destitute of friendship; he thinks and acts for himself alone.

From *Encyclopaedia Britannica*, 3rd edition, 1787

33. Katsukawa Shunsho,
Cat Licking its Paw.
Hanging scroll, ink and colours
on paper, Japan, AD 1790.

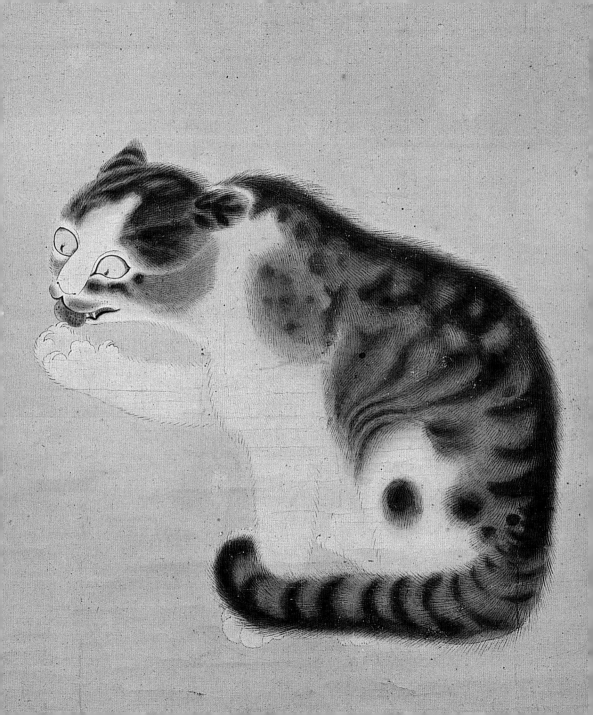

Feline Delinquency

I cannot agree that it should be the declared public policy of Illinois that a cat visiting a neighbor's yard or crossing the highways is a public nuisance. It is in the nature of cats to do a certain amount of unescorted roaming. Many live with their owners in apartments or other restricted premises, and I doubt if we want to make their every brief foray an opportunity for a small game hunt by zealous citizens – with traps or otherwise. I am afraid this Bill could only create discord, recrimination and enmity. Also consider the owner's dilemma: To escort a cat abroad on a leash is against the nature of the cat, and to permit it to venture forth for exercise unattended into a night of new dangers is against the nature of the owner. Moreover, cats perform useful service, particularly in rural areas, in combating rodents – work they necessarily perform alone and without regard for property lines.

We are all interested in protecting certain varieties of birds. That cats destroy some birds, I well know, but I believe this legislation would further but little the worthy cause to which its proponents give such unselfish effort. The problem of cat versus bird is as old as time. If we attempt to resolve it by legislation who knows but what we may be called upon to take sides as well in the age old problems of dog versus cat, bird versus bird, or even bird versus worm. In my opinion, the State of Illinois and its local governing bodies already have enough to do without trying to control feline delinquency.

Adlai Stevenson (1900–65)
Veto message ('The Cat Bill Veto')
April 23, 1949

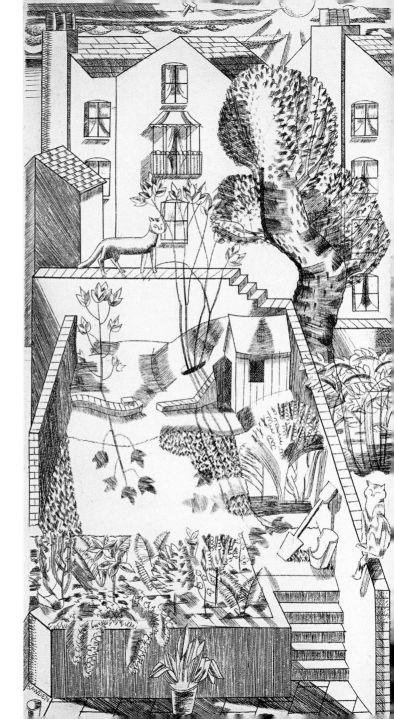

34. Edward Bawden,
London Back Garden (detail).
England, 1927–29.

Cat-Goddesses

A perverse habit of cat-goddesses –
Even the blackest of them, black as coals
Save for a new moon blazing on each breast,
With coral tongues and beryl eyes like lamps,
Long-legged, pacing three by three in nines –
This obstinate habit is to yield themselves,
In ver-similar love-ecstasies,
To tatter-eared and slinking alley-toms
No less below the common run of cats
Than they above it; which they do for spite,
To provoke jealousy – not the least abashed
By such gross-headed, rabbit-coloured litters
As soon they shall be happy to desert.

Robert Graves (1895–1985)

35. Bronze figure of the
goddess Bastet with kittens.
Egypt, Late Period – Ptolemaic
period, c.664–30 BC

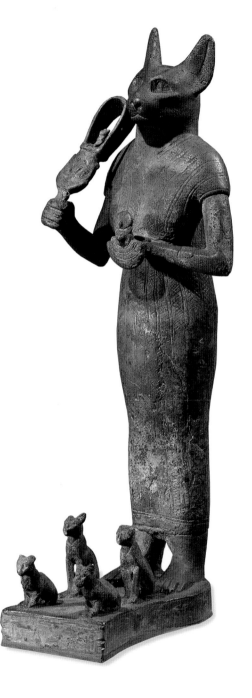

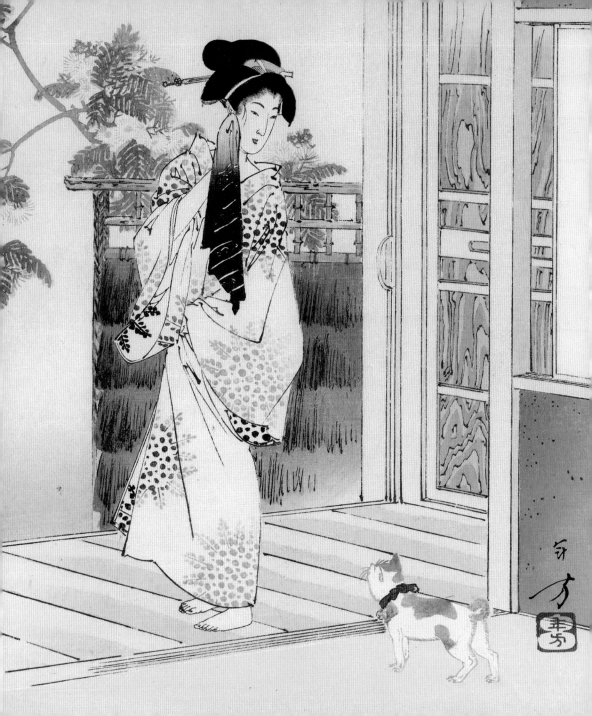

Cat and Paramour

Make fast your door with bars of iron quite;
No architect can build a door so tight
But cat and paramour will get through in spite.

Apollodorus of Carystus (fl. *c*.300–260 BC)

36. Mizuno Toshikata,
Girl with Cat,
Colour woodblock print
from the series *The Thirty-six
Beauties Compared*,
Japan, 19th century

Critics and Censors

Cats as a class have never completely got over the snootiness caused by the fact that in ancient Egypt they were worshipped as gods. This makes them far too prone to set themselves up as critics and censors of the frail and erring human beings whose lot they share. They stare rebukingly. They view with concern. And on a sensitive man this often has the worst effect, including an inferiority complex of the gravest kind...

Webster was very large and very black and very composed. He conveyed the impression of being a cat of deep reserves. Descendant of a long line of ecclesiastical ancestors who had conducted their decorous courtships beneath the shadow of cathedrals and on the back walls of bishops' palaces, he had that exquisite poise which one sees in high dignitaries of the Church. His eyes were clear and steady, and seemed to pierce to the the very roots of the young man's soul, filling him with guilt.

P.G. Wodehouse (1881–1975)
From *The Story of Webster*, 1933

37. Bronze statuette
of a cat.
Egypt, Late Period
(747–332 BC)

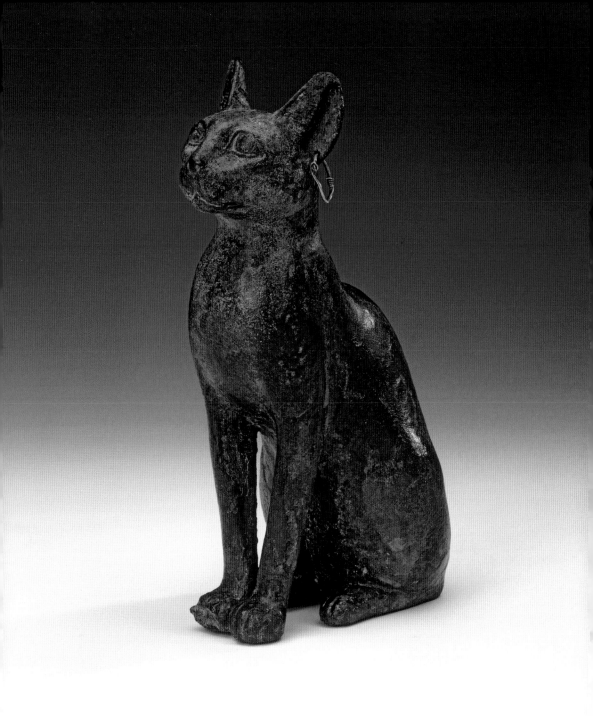

A Poet's Cat

A poet's cat, sedate and grave
As poet well could wish to have,
Was much addicted to inquire
For nooks to which she might retire,
And where, secure as mouse in chink,
She might repose, or sit and think.
I know not where she caught the trick –
Nature perhaps herself had cast her
In such a mould *philosophique*,
Or else she learn'd it of her master.
Sometimes ascending, debonair,
A apple tree or lofty pear,
Lodged with convenience in the fork,
She watched the gardener at his work;
Sometimes her ease and solace sought
In an old empty watering pot;
There, wanting nothing save a fan,
To seem some nymph in her sedan
Apparelled in exactest sort,
And ready to be borne to court.

William Cowper (1731–1800)
From *The Retired Cat*, 1791

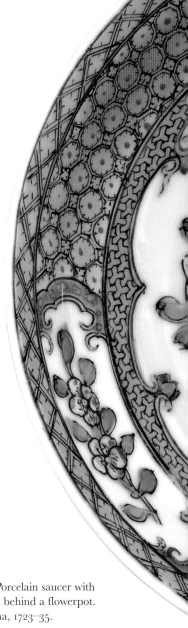

38. Porcelain saucer with
a cat behind a flowerpot.
China, 1723–35.

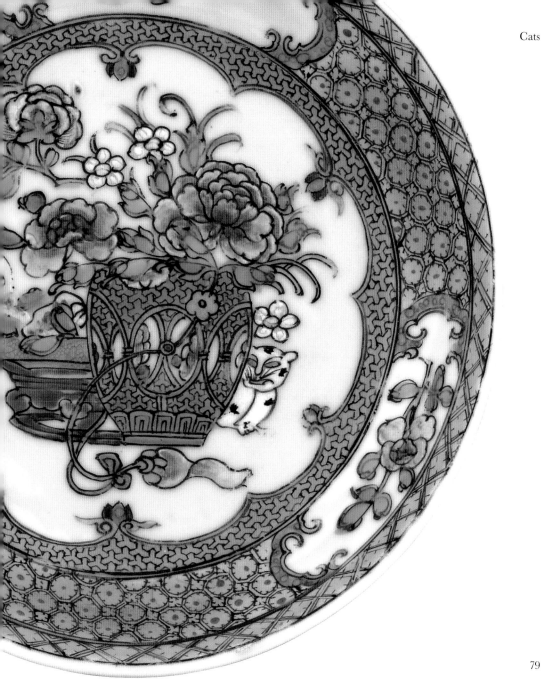

Theatre Cats

Curiously, and perversely enough, the cat, who elsewhere often signifies the most dread disaster, is a harbinger of prosperity in the theatre. A black cat is preferred; indeed, the mere presence of a black cat is sufficient to insure the success of any playhouse or any play. However a cat of another colour will do. This superstition is so wide-spread that every theatre from the Comédie Française to the People's Theatre on the New York Bowery entertains a cat, feeding her lavishly, and treating her with a respect and consideration which she seldom receives elsewhere. I myself have known a stage carpenter in the Apollo Theatre at Atlantic City to go to the butcher and spend his own money for fresh liver with which he returned to feed the cat before he went off to his own dinner...

If the pampered feline goes so far as to condescend a caress, rubbing herself against an actor's leg, that actor may be practically certain that David Belasco will send for him in the morning to sign a life-contract. Thus a kitten which playfully attached itself to the trailing skirt of Florence Reed's dress during a rehearsal of Seven Days is said to have been responsible for the subsequent success of that happy farce and the call-boy himself could have told you that Florence Reed would later become a star... At the first New York performance of Henry Irving in Faust the theatre cat wandered out on the open stage during the first scene; undisturbed by the thunder and lightning, from the vantage point of a canvas rock, she regarded the action with dignity and decorum. Irving afterwards remarked that he had regarded the incident as a lucky omen.

Carl Van Vechten (1880–1964).
From *The Tiger in the House*, 1922

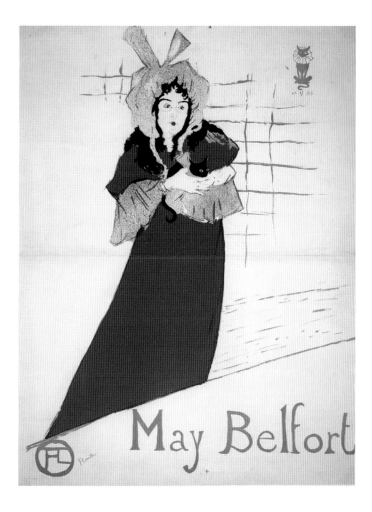

39. Henri de
Toulouse-Lautrec,
May Belfort.
Colour lithograph,
Paris, France, 1895.

For there is nothing sweeter than his peace when at rest.

Christopher Smart (1722–1771)
From *Jubilate Agno*, *c*.1760

40. Kawanabe Kyosai,
Sleeping Cat.
Colour woodblock, Japan,
1885–9.

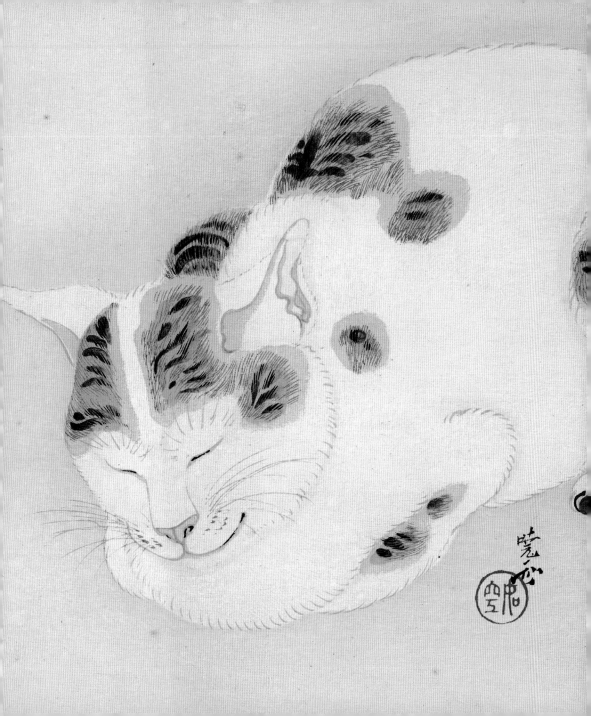

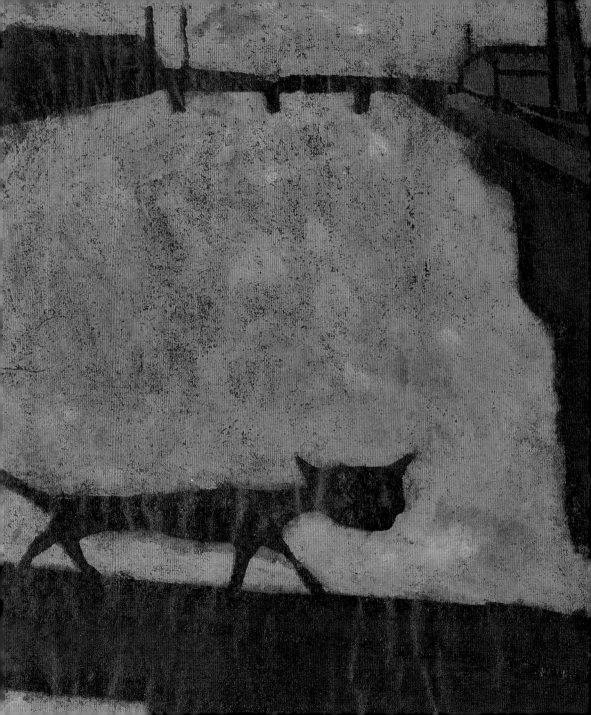

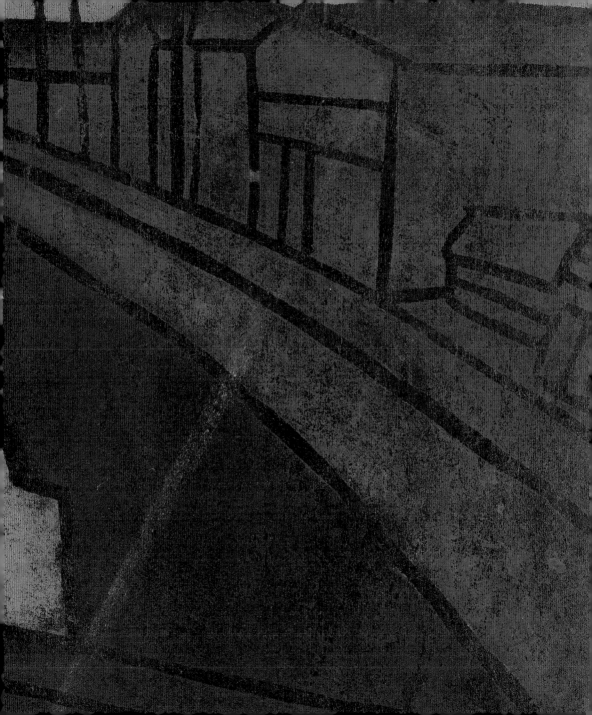

Notes and Acknowledgements

The publishers have made every effort to contact the copyright-holders of material published in this volume. They will be pleased to hear from any copyright-holder who has not been successfully located prior to publication.

All the photographs in this book were taken by the British Museum Photography and Imaging Department and are copyright the Trustees of the British Museum, unless otherwise stated below.

page 9, no 1
Leonardo da Vinci was one of the outstanding figures of the Italian Renaissance. This drawing, acquired by the British Museum in 1856, may have been a study for a painting of the Virgin and Child in a domestic setting. It shows the seated Virgin holding the Christ Child on her right knee; the Child in turn grasps a cat which struggles to escape. The symbolism of the cat here is not entirely clear, but in Renaissance art a cat often represented the love of liberty.

From *The Notebooks of Leonardo da Vinci* (1452–1519), edited by Irma A. Richter (OUP, 1952). 1856,0621.1 recto.

pages 10–11, no. 2
Sylvia Townsend Warner is best known for her highly individual novels, stories and poems. For over forty years she contributed short stories to the New Yorker, and enjoyed a regular and lively correspondence with the magazine's editor, William Maxwell. From

Michael Steinman, ed., *The Element of Lavishness: Letters of William Maxwell and Sylvia Townsend Warner, 1938–1978*, Counterpoint, Washington DC, 2001. Sylvia Townsend Warner letters copyright 1982, 2000 by Susanna Pinney, Executor of the Estate of Sylvia Townsend Warner.

The British artist Christopher Wood (1901–1930) was a painter of landscapes, harbour scenes and figure compositions. He established an early reputation in the art world but died young and is remembered as a youthful genius who never achieved his full potential. 1954,0928.1.

pages 12–13, no. 3
The French poet Charles Baudelaire was one of the most influential writers of the 19th century. Dark and erotic, his verse and prose poetry was widely regarded as the embodiment of vice and depravity. Many critics, however, now regard him as the first truly modern poet.

Théophile Steinlen (1859–1923) was a Swiss-born

illustrator, printmaker, painter and sculptor who spent most of his life in Paris. 1949,0411.3483.

pages 14–15, no. 4

Kobayashi Issa 'Cup of Tea' was one of the foremost haiku poets of the Edo period (1600–1868). A haiku is an epigrammatic verse comprising three lines of five, seven and five syllables; it must also contain a special 'season' word describing the season in which the poem is set – in this case, New Year.

Utagawa Hiroshige (1797–1858) was a contemporary of Issa's and one of the foremost artists of the Ukiyo-e ('Floating World') school, which depicted scenes from everyday life in Edo (Tokyo). This print from the series 'One Hundred Famous Views of Edo' shows a Japanese Bobtail cat – itself a symbol of good luck – sitting at a window with a distant view of Fuji. In the middle distance is a winding procession celebrating the Torinomachi festival, held

shortly before New Year. 1906,1220,0.664, Rogers Fund 1914.JP60.

pages 16–17, no. 5

The British naturalist Thomas Brown was the curator of the Manchester Museum from 1838, and was the author of several works on natural history. The scene comes from an ancient Egyptian papyrus document satirizing society during the reigns of the last Ramesside kings. The drawings show animal figures in situations that reverse the natural order: here, a loving cat holds a duckling in her arms while tenderly escorting her brood. EA 10016.

pages 18–19, no. 6

Lewis Carroll, real name Charles Lutwidge Dodgson, was an Oxford mathematician who became better known for his fantastical tales and nonsense verse. *Alice's Adventures in Wonderland* was written for Alice Liddell, the daughter of a fellow don.

The illustrator was the eminent political cartoonist

Sir John Tenniel (1820–1914). His drawings were engraved by the Dalziel Brothers engraving company, founded in 1839 and renowned for its book illustrations. 1957,0308.5.

pages 20–21, no. 7

John Keats was one of the foremost poets of the English Romantic movement and a confirmed cat-lover. This affectionate portrait of an elderly cat was written as a humorous exercise in the Miltonic sonnet-form which Keats was to use for his epic work 'Hyperion'. Composed in 1818, it was first published in *The Comic Annual* in 1830, nine years after the poet's death.

Cornelis Visscher (1628–58) was a Dutch engraver from a long line of artists. Like John Keats, Visscher died young; this plate was produced shortly before his death. 1848,1125.48.

pages 22–23, no. 8

According to Herodotus, Aesop was a slave who lived on the Greek island of Samos during the 6th century BC. He gained fame as the composer

of fables – short tales, often featuring birds and animals, that illustrated truths about life and human nature – and was eventually freed by his master. Opinion is divided on whether Aesop ever existed; even if he did, it is unlikely that one person could have created all the fables attributed to his name. Joseph Jacobs, *Aesop: Fables*, The Harvard Classics, 1909–14.

Francis Barlow (1626–1704) was England's leading bird and animal artist in the 17th century. This drawing is taken from his series illustrating *Aesop's Fables*, published in 1666. 1867,0413.361.

pages 24–5, no. 9
Rainer Maria Rilke, born René Karl Wilhelm Johann Joseph Maria Rilke in Prague in 1875, is considered by many to be the greatest German lyric poet of the 20th century, though he lived in Paris for most of his life. Rilke's unique contribution to literature was his creation of the 'object poem': an attempt to describe physical objects with the

utmost clarity, to capture the 'silence' of their 'concentrated reality'. Rilke, Rainer Maria. *Ahead of All Parting: The Selected Poetry and Prose of Rainer Maria Rilke*. Trans. Stephen Mitchell. New York: The Modern Library, 1995.

Maeda Masao (1904–1974) was a Japanese woodblock artist from the island of Hokkaido. The simplicity of this print reflects the austerity of the post-war period in Japan. 1987,0316,0.535 © The Estate of Maeda Masao.

pages 26–7, no. 10
Edward Topsell was a 17th-century clergyman with a fascination for natural history. His major works were written during a transitional time for science, and while they show the beginnings of a modern scientific approach, Topsell was still keen to cite the authority of Classical sources.

Théophile Steinlen: see note to pp. 12–13, no. 3, on previous page. 1949,0411.4999.

pages 28–9, no. 11
William Blake was a poet, painter, engraver and mystic. He wrote, printed and illustrated his own books, in which he railed against the rationalism and materialism of the industrial age. 'The Tiger' is taken from his *Songs of Experience* (1794).

The Japanese painter Gan Ku (1749–1838) was strongly influenced by the Nagasaki style, a Chinese academic style first introduced into the Japanese city of Nagasaki in the early 1730s. Tiger paintings were very popular in Japan, but as the artists would never have seen a real tiger, they must have worked from skins. 1931.0427,0.1.

pages 30–31, no. 12
Mark Twain was the pen name of Samuel Longhorne Clemens (1835–1910), the American author and humourist best known for his books *Tom Sawyer* and *The Adventures of Huckleberry Finn*. During his long and colourful career he travelled extensively and tried many

occupations (including a brief and unsuccessful period as a miner) which later provided much of the material for his writing. This print, from an unidentified publication, was engraved by William Raddon after a painting by Abraham Cooper (1787–1868) and published by William Bernard Cooke of Soho Square, London. 1866,0407.1000.

The Buffalo *Express*, 18 December 1869.

pages 32–3, no. 13

Paul Gallico was a prolific and successful American writer; he is best remembered for *The Snow Goose*. A noted cat-lover, he published several books featuring cats. Paul Gallico, *My Boss, the Cat*, Gillon Aitken Associates Ltd, copyright Mathemata AG 1964.

Orovida Camille Pissarro (1893–1968) was the grand-daughter of the famous Impressionist Camille Pissarro. Born in England, she lived and worked mainly in London. At first she followed the family tradition, painting in the Impressionist manner, but soon developed her own distinctive style. 1960,0409.314. © The Estate of Orovida Camille Pissarro.

pages 34–5, no. 14

Ernest Alfred Wallis Budge was Keeper of Egyptian and Assyrian Antiquities at the British Museum from 1894–1924; he was knighted in 1920.

The Egyptian goddess Sekhmet (meaning 'she who is powerful') was the protector of the king, and is usually represented as a lioness-headed woman. This black granite seated figure was originally erected in the memorial temple of the pharaoh Amenhotep III (1390–1352 BC) in Western Thebes. Sekhmet's feline companion is not a British Museum resident, but a (specially permitted) visitor: the late lamented Domino, former housemate of BMP editor Carolyn Jones. Photo by Peter Hayman. Statue: EA 517.

pages 36–7, no. 15

The *Instruction of Ankhsheshonq*, contained in Papyrus British Museum 10508, is a late example from a long tradition of Egyptian 'wisdom literature' stretching back to the Middle Kingdom. These texts were often set as practice exercises for trainee scribes. Translated from the Demotic by Miriam Lichtheim, in *Ancient Egyptian Literature, vol. III, The Late Period*, University of California Press, 1980.

The 'scribe and counter of grain' Nebamun, shown here with his wife Hatshepsut and their daughter, would certainly have been familiar with such literary works. In this scene from his tomb chapel, the family cat joins enthusiastically in a hunting trip on the river. EA 37977.

page 38, no 16

The Greek traveller and historian Herodotus is best known for his *Histories* which narrate the wars between Greece and Persia that wracked the eastern Mediterranean in the 5th century BC. While travelling to collect material for this work, Herodotus visited Egypt,

where he was fascinated by religious practices such as animal worship and mummification. From *Histories* II.65–67, translated by Aubrey de Sélincourt (1954). Revised edition, Penguin Classics 1972. © The estate of Aubrey de Sélincourt, 1954. © A.R. Burn, 1972. Reproduced by permission of Penguin Books Ltd.

In ancient Egypt every year thousands of cat mummies, dedicated to the goddess Bastet, were interred in catacombs close to her temple at Bubastis and elsewhere. EA 37348.

page 39, no. 17
Hywel Dda (Hywel the Good) was a 10th-century king of South Wales responsible for establishing three regional codes of law: the Venedotian, Dimetian, and Gwentian. The first of the extracts given here is from the Venedotian Code, and the second from the Dimetian Code.

The first British 10 pence coins were issued in 1968 in anticipation of decimalization in 1971 and replaced the pre-decimal florin, or 2 shilling coin. The reverse of the coin, shown here, was designed by Christopher Ironside, and features a crowned lion passant gardant derived from the crest of England (for the coat of arms of Queen Elizabeth I, see note to pages 48–9, no. 22). 1992,1145.2.

pages 40–41, no. 18
The Scots writer and lawyer James Boswell is best remembered today as the biographer of Dr Samuel Johnson (1709–1784), one of the outstanding figures of English literature. A lawyer, poet, essayist, critic and journalist, Johnson's greatest achievement was the compilation of the first dictionary of the English language. He was a lively and entertaining conversationalist, and, thanks to Boswell, much of his wit and wisdom was recorded for posterity.

The cat-shaped nightlight holder, made of brown-black enamelled porcelain, was made in China during the Qing Dynasty (ad 1662–1722). 1936,1012.109.

pages 42–3, no. 19
Izaak Walton's *Compleat Angler* (1653) not only describes the technique of angling, but contains many enjoyable digressions, including this consideration of some of the views held by the prominent French renaissance thinker Michel Yquem de Montaigne (1533–1592). Montaigne argued against the doctrine that man is superior to the animals, as is well illustrated here.

Domesticated cats like the one on this Campanian-style vase were introduced to southern Europe from Egypt from the 5th century BC, and gradually replaced the ferrets formerly kept to control vermin. 1867,0508.1284.

pages 44–5, no. 20
Philip M. Rule was a 19th-century British naturalist.

Yamamoto Ranei was a minor artist of the Kano school, which combined a Chinese academic style of ink painting with decorative

elements and the use of polychrome derived from Japanese traditions. He later switched to painting Ukiyo-e (see note to no. 4, pp. 14–15). 1881,1210,0.804.

pages 46–7, no. 21
The wave of witch-hunting hysteria that swept the small Massachusetts town of Salem in the summer of 1692 is one of the most curious episodes of American history. Between June and September of that year, nineteen townspeople (including Susanna Martin) were hanged, one was crushed by rocks, and several died in prison awaiting trial on charges on witchcraft and devil-worship. The accusations, none of which seem to have been based in fact, were given the semblance of credibility by the exaggerated evidence of witnesses and confessions extracted under torture.

Cotton Mather, *Wonders of the Invisible World* (Boston, 1693), and Cotton Mather, *Memorable Providences, Relating to Witchcraft and Possessions* (Boston, 1689), reprinted in George Lincoln

Burr, ed., *Narratives of Witchcraft Cases*, 1648–1706 (New York, 1914), 229–36, 103–106.

Théodule-Augustin Ribot (1823–1891) was a French *realist* painter and printmaker. He preferred to work directly from nature, often at night by lamplight, using the contrasts of light and dark to create atmosphere and suggest psychological states. 1998,0711.1.

pages 48–9, no. 22
Rudyard Kipling (1865–1936) was a popular English writer of poems, novels and short stories for both adults and children. Much of his work was inspired by his early life in India. In 1907, he became the first English-language writer to be awarded the Nobel Prize for Literature. Rudyard Kipling, *Just So Stories*, Macmillan & Co, 1902.

Tadashige Ono (1909–1990) was a leading figure in Japanese printmaking in the second half of the 20th century. Strongly influenced by the socialist-inspired art movements of prewar Europe,

Ono's vision of Japan takes the form of industrial cityscapes in sombre tones, rather than the traditional idealised landscapes. 1986,0321,0.556 © The Estate of Tadashige Ono.

pages 50–51, no. 23
Scroll paintings are still used by traditional storytellers in rural India to illustrate their narratives. This scroll from Bengal depicts the legend of Gazi, a local Muslim saint whose many miraculous feats included overpowering such dangerous animals as tigers and snakes. 1955,1008,0.95.

pages 52–3, no. 24
Medieval bestiaries were illuminated manuscripts describing the birds, animals and fish to be found in nature. For Christians of the time, the natural world, or 'book of nature', had been arranged by God to provide instruction to humanity; here, for example, the tigress is shown as a model of motherly devotion. Translation copyright 1995 Colin McLaren and Aberdeen

University Library.

The Hoxne hoard was a spectacular find of buried coins, silver jewellery and tableware unearthed by archaeologists at Hoxne, Suffolk, in 1992. The silver tigress would have been made as one of a pair of handles for a large vase or amphora. The treasure may have been buried during the social upheaval that accompanied the end of Roman rule in Britain. 1994,0408.30.

pages 54–5, no. 25

Erwin Schrödinger (1887–1961) was an Austrian physicist; in 1933 he shared a Nobel prize for his achievements in the field. In 1935 he proposed this thought experiment to illustrate the principle of superposition in quantum physics: it demonstrates the apparent conflict between what quantum theory tells us is true about the nature and behaviour of matter on the microscopic level and what we observe to be true on the macroscopic level.

The American writer Bill Bryson is well known for his many popular and humorous books on subjects as varied as travel, language and science. *A Short History of Nearly Everything* has won numerous awards for Bryson's achievement in making complex scientific topics accessible to a lay audience. Bill Bryson, *A Short History of Nearly Everything*, Doubleday/ Transworld, London, 2003.

George Cruikshank (1792– 1878) was a British printmaker best known for his political satires and caricatures. He was also a highly successful book illustrator who won international recognition for his illustrations to Daniel Defoe's *Robinson Crusoe* (1831), and Charles Dickens's *Oliver Twist* (1838). 1978,U.556.

pages 56–7, no. 26

Dating from the middle of the 18th century BC, this letter written in cuneiform script on a clay tablet is one of over 3,000 found in the archives of the royal palace of Mari (on the banks of the River Euphrates in modern Iraq). *Letters from Mesopotamia: Official, Business and Private Letters on Clay Tablets from Two Millennia, Translated and with an Introduction by A. Leo Oppenheim*, University of Chicago Press, 1967. Published by courtesy of Oriental Institute Publications, Chicago IL.

The bronze lion weight is one of a group of sixteen discovered buried under a colossal stone bull in the Assyrian city of Nimrud. 1848,1104.68.

pages 58–9, no. 27

This extract from Shakespeare's *Henry V* is taken from one of the play's most famous speeches: as the King addresses his army before the battle of Harfleur ('Once more unto the breach, dear friends…') he uses the image of the tiger to awake their fighting spirit.

Orovida Camille Pissarro: see note to pages 32–3, no. 13. 1960,0409.252. © The Estate of Orovida Camille Pissarro.

pages 60–61, no. 28

Sir Alexander Gray was a

Scots academic and writer whose work covered an extremely broad spectrum. An economist and civil servant by training, he became Professor of Political Economy first at Aberdeen University, and then at Edinburgh. In addition, he wrote original poetry in English, and made Scots translations of the poetry, folk songs and ballads of Denmark and Germany. The Gray family cats were always named after minor Old Testament prophets, and the subject of this poem rejoiced in the name Nahum, son of Micah. Published by courtesy of John Gray.

The British painter, illustrator and graphic artist Edward Bawden (1903–1989) studied at the Royal College of Art under Paul Nash, and is best known for his London Underground posters. 1987,1212.7 © The Estate of Edward Bawden.

page 62, no. 29
Sir Philip Sidney (1554–86), was an English statesman, soldier, courtier and poet in the reign of Elizabeth I. Sidney was a generous patron of contemporary poets, but his own work, written between 1578 and 1582, was not published until after his death. This extract is taken from *Arcadia*, an unfinished pastoral romance.

A part of traditional Japanese costume, netsuke are decorative toggles used to keep in place accessories hung from the sash of a kimono. Ivory was a popular material for netsuke, along with wood, amber, stone, coral, tortoiseshell and even cast-bronze. HG.700.

page 63, no. 30
'Jubilate Agno' (Rejoice in the Lamb) by the 18th-century English poet Christopher Smart praises the divine architecture of the natural world. This remarkable work remained unknown for many years and was not published until 1939. This line is from a long section devoted to Smart's cat Jeoffry. From 'Jubilate Agno', in Karina Williamson, ed., *The Poetical Works of Christopher Smart*, Clarendon Press, Oxford, 1980.

George Scharf I was a German-born artist who emigrated to England in 1816 after serving as a draughtsman in the British Army. He is best known for his closely-observed scenes of everyday life. 1900,0725.5.

pages 64–5, no. 31
One of the first writers to attempt to demystify and popularise medicine, William Salmon was a successful 17th-century astrologer and apothecary who translated many earlier medical and pharmacological texts to produce his own works. *The Compleat English Physician* contains over a thousand pages of entries on the medicinal uses of animal, plant and mineral ingredients.

Chinese hanging scrolls such as this one, painted by Ying Chen in the 19th century, were intended to be viewed by a group of people together. 1910,0212.0567.

pages 66–7, no. 32
Marriott Edgar was a Scots writer and comedian best known for his humorous monologues, of which 'The Lion and Albert' is perhaps the most famous. 'The Lion and Albert'. Words by George Marriott Edgar. © 1933. Reproduced by permission of Francis Day & Hunter Ltd, London WC2H 0QY.

The Flemish Baroque painter Peter Paul Rubens (1577–1640) is best known for his monumental paintings of religious and mythological subjects, though he also painted landscapes and portraits. Rubens enjoyed drawing wild animals and incorporated them in many of his works, especially his hunting scenes. Oo.9.35.

pages 68–9, no. 33
The *Encyclopaedia Britannica* is the oldest and largest general encyclopaedia in the English language. Its three-volume first edition was published in Edinburgh, Scotland, between 1768–71. Now published in Chicago, USA, the Encyclopaedia is currently in its 15th edition.

Katsukawa Shunsho (1726–92) was a Japanese painter and printmaker of the Ukiyo-e ('Floating World') school based in Edo (modern Tokyo). He was noted for his woodblock prints of actors, and taught many artists including Hokusai. This paper hanging scroll was made by him in 1790. 1982,0701.16.

pages 70–71, no. 34
Adlai Ewing Stevenson II, Governor of Illinois from 1949–53, is best remembered for his skill in debate and oratory; his renowned humour and wisdom shine through in this message of 1949 vetoing Senate Bill No. 93, entitled *An Act to Provide Protection to Insectivorous Birds by Restraining Cats*, which proposed the imposition of fines on owners who permitted their cats to roam at large, and would have allowed any person to trap or otherwise capture cats found straying. *The Papers of Adlai E. Stevenson*, ed. Walter Johnson, vol. 3, pp. 73–4 (1973).

Edward Bawden: see note to pages 60–61, no. 28. 1987,1212.14 © The Estate of Edward Bawden.

pages 72–3, no. 35
Best known for his historical novels *I, Claudius* and *Claudius the God*, Robert Ranke Graves was an English poet and novelist as well as a classical scholar who translated numerous Greek and Latin works. Graves was a professor of English in Cairo in the years after World War I, and would have been familiar with images of the ancient Egyptian cat-goddess Bastet. Robert Graves, *Collected Poems* (Cassell, 1975).

This 'housewife' image of Bastet as a cat-headed woman accompanied by a litter of kittens emphasizes her role as a goddess of motherhood. EA 25565.

pages 74–5, no. 36
Apollodorus of Carystus was a Greek playwright of the new Attic comedy. Today little is known of his life or his work, which mainly survives only in

fragments. However, he was a prolific and influential figure; he is known to have written forty-seven plays, five of which won prizes.

Mizuno Toshikata (1866–1908) was a Japanese illustrator, painter and printmaker. Born in Tokyo, he was apprenticed at 13 to the printmaker Tsukioska Yoshitoshi; in 1877, following in the footsteps of his master, he became an illustrator for the Tokyo newspaper *Yamato shinbun*. Mizuno produced several series of genre scenes featuring women and children, but is perhaps best known for his depictions of the Sino-Japanese war of 1894–95. 1906,1220,0.1544.

pages 76–7, no. 37
Pelham Grenville Wodehouse, always known as either P.G. Wodehouse or simply 'Plum', was born in England, but settled in the USA and became an American citizen. He is best known for his Jeeves and Wooster stories, but created many other comic characters who appeared in his

numerous short stories. 'The Story of Webster', in *The World of Mr Mulliner*, pub. Barrie and Jenkins by permission of the Random House Group and AP Watt on behalf of the trustees of the Wodehouse estate.

The bronze figurine of the goddess Bastet, in the form of a seated cat, was made in Egypt during the Late Period (c.747–c.332 BC). Its pierced ears contain gold wire earrings. EA 58517.

pages 78–9, no. 38
The poet William Cowper began his career as a lawyer, but episodes of severe depression led him to move to the country where he concentrated on writing and translating the classics. By choosing his subjects from everyday life and the English counryside, Cowper took English poetry in a new direction. It is as a 'nature poet' that he is best remembered.

The enamelled and gilded porcelain saucer was made in China around 1723–35, during

the Qing dynasty. Franks.439.

pages 80–81, no. 39
Carl Van Vechten was an American writer-turned-photographer who specialised in portraits of celebrities, especially the black artists of the Harlem Renaissance; the Library of Congress holds an archive containing over a thousand of his photographs. The quotation comes from *The Tiger in the House*, published in several editions by Jonathan Cape in the 1920s and 1930s.

Like Van Vechten, the French painter and lithographer Henri de Toulouse-Lautrec (1864–1901) was drawn to the colourful world of nightclubs and cabarets. At the Cabaret des Decadents in Paris, he met and drew the Irish singer May Belfort (real name May Egan). In this print, later used as a poster for the Petit Casino, she is shown performing the popular song 'Daddy Wouldn't Buy Me a Bow-wow', during which she appeared on stage dressed in baby clothes and carrying a small black cat. It

appears that Miss Belfort was
a cat-lover offstage, too, for
Toulouse-Lautrec wrote on
her behalf to a friend: 'Miss
Belfort demande un époux
pour sa chatte. Est ce que
votre chat de Siam est mur
pour la chose? Un petit mot
s.v.p. et fixez-nous un rendez-
vous.' 1925,1007.3.

pages 82–3, no. 40
Christopher Smart: see note to
page 63, no. 30.
 This charming colour
woodblock print of a happily
sleeping cat was made by
Kawanabe Kyosai, a Japanese
artist who worked during the
Meiji period, about ad 1871–
89. 1881,1210,0.785 (on loan to
the Asia Department of the
British Museum).

pages 84–5
Tadashige Ono, *River* (detail),
Japan, 1957. 1986,0321,0.556
© The Estate of Tadashige
Ono